T0208357

ART NINJA

ART NINJA

Seeing as an Artist

PHYLLIS P. MILLER

ARCHWAY
PUBLISHING

Copyright © 2016 Phyllis P. Miller.

All rights reserved. No part of this book may be used or reproduced by any means, graphic, electronic, or mechanical, including photocopying, recording, taping or by any information storage retrieval system without the written permission of the author except in the case of brief quotations embodied in critical articles and reviews.

Archway Publishing books may be ordered through booksellers or by contacting:

Archway Publishing
1663 Liberty Drive
Bloomington, IN 47403
www.archwaypublishing.com
1 (888) 242-5904

Because of the dynamic nature of the Internet, any web addresses or links contained in this book may have changed since publication and may no longer be valid. The views expressed in this work are solely those of the author and do not necessarily reflect the views of the publisher, and the publisher hereby disclaims any responsibility for them.

Any people depicted in stock imagery provided by Thinkstock are models, and such images are being used for illustrative purposes only.
Certain stock imagery © Thinkstock.

ISBN: 978-1-4808-3882-6 (sc)
ISBN: 978-1-4808-3883-3 (e)

Library of Congress Control Number: 2016917437

Print information available on the last page.

Archway Publishing rev. date: 11/08/2016

Dedicated to all my students I have taught throughout
the years. I studied art to bring art to each of you. My wish is
that each person using this workbook takes what is learned
and surpasses me. Keep the joy of art in your life!

This book would not have been possible without the support of family, friends, and former teammates from my years of teaching. Others who have unknowingly helped me are Vickie and Norm Sherratt, who allowed me to photograph their farm animals. That one act of kindness became the final piece I needed to start this book. I want to thank the owners of Gardner Village in West Jordan, Utah, who gave their consent to use photos I took on their premises. A special thanks to the Natural History Museum of Utah at the University of Utah for the use of the dinosaur picture and Hogle Zoo in Salt Lake City, Utah, for letting me use the picture of the bear. I appreciate my daughter, Emerlie, and son, Shan, for allowing me to include their pictures, they took while on vacation in California. Gratitude to my other daughter, Kalia, for the use of the photo I took of her in Southern Utah. Last of all, I would like to express my gratitude to Kalia's friend, Annie, and her husband, Bryce, for their positive attitude in allowing me to take pictures of their chickens and using one in this book.

CONTENTS

CONTENTS

INTRODUCTION

So you want to be an artist! This book is for you. Inside you will find projects to open up your eyes of understanding to see as an artist. I know these exercises can work, because I have used these very lessons with many elementary students and myself. In all the years I have used these methods, I have never had a student who did not improve in his/her art skills. That means it could happen for you. Art is like a sport. In order to do a sport well, you need to practice. Spend several days on each art skill. Keep your drawings and watch your improvement over time.

Why are these skills important to learn today? Because most people still draw the same as they did in fourth to sixth grade. However, if you can learn to see like an artist, you will not regress. You will surpass the drawing skills of a majority of people in this world.

All my life I was obsessed with paper, pencils, crayons, and paints. I remember the day my father, who was a bus driver, principal, and teacher all at the same time, took me to the supply closet at his school. He told me to take what I wanted, but not to overdo it. I was frugal, but the overwhelming joy I felt inside was indescribable.

Although I was enthralled with every aspect of art, I was always the child who would look at my neighbor's paper in school and think, *Why can't I draw like that?* It was not until I did art for some time as an adult that I experienced that same feeling in a different way. I was in a one-hour art class drawing a picture using pastels. You can imagine my shock when the teacher next to me kept glancing at my picture and hogged the pastels. She hovered over them, daring me to grab one. I laughed. *My goodness,* I thought, *she's jealous of me.*

I had always been critical of what I produced. Amazingly, I realized by teaching numerous students that there was not a right or wrong to each drawing. Each student's artwork was unique—not good or bad, just different. I had my preferences as to which pictures I liked better, but only because some art was more appealing to me. They appealed to me because of my personality just as someone else would choose other art because of his or her personality.

I spent hours going to art galleries and reading about art in books. Occasionally, I would run across art that did not make sense to me. The first one was at the Smithsonian Museum of Modern Art. One small white room had strands of yarn hanging from the ceiling. In another room was a huge square of bright yellow hazelnut tree pollen, about one-inch thick, covering the middle of the floor. Other art pieces were in the Seattle Museum of Art. White full-sized cars were hanging from the ceiling with light rods protruding out of them. Then there was a toilet with miscellaneous objects inside the bowl. I found several paintings and sculptures that did not intrigue me in the least. I told myself, "If they call that good art, then I can be an artist."

One obstacle I had to overcome was never being able to make the picture the same as the artwork in my mind's gallery. A moment of awakening came when I was reading a book about art. The author stated that not being able to make an art piece, as well as what one visualizes in his/her mind is a common problem for artists. That is the very reason that keeps an artist motivated to make art. As you apply the lessons in this workbook, challenge yourself to do better and better. It is that unsatisfied feeling you get that will drive you to perfecting your skills.

CHAPTER 1

STARTING POINT

This book is for anyone who wants to learn art, both young and old. Put the lessons in this book to the test. Do not compare your drawings with anyone else's. Exercises in this book each have a purpose. You may not see a difference in your art at first, but I promise that by doing these exercises, you will develop artist's eyes. Most of all, keep in mind, it takes time and practice.

The first few drawings may be "lousy" in your opinion. Did it not take practice to learn to read and write? How about learning how to play a sport well? You may be a beginner in art. So what? People who have a natural talent do not always have the drive that a person who has a strong desire to succeed possesses. Ask yourself, "Why not me?" Is becoming an artist important to you?

You have to discover which type of art is best suited for you. Try using pencils, paints, chalks, colored pencils, and charcoals. You may find you like something that you never intended to enjoy. Start with the basics of drawing and seeing. Then move on to explore art in all mediums.

For years, I never wanted to use oils or paint portraits. I put off taking art lessons from an experienced oil painting teacher because of my preconceptions. My preference was watercolor classes. However, because of my full-time teaching job, oil classes were all that were available. The oil painting teacher convinced me to try oils. I do not regret taking her advice. I found that oils were versatile and gave results that other mediums could not give. My teacher, Linda, challenged me to do portraits. I was skeptical at first, but I tried. I ended up doing three portraits while under her expert direction. I have continued doing portraits on my own. I will always be grateful for a teacher who pushed me beyond my comfort zone.

The most confining limits are the ones we place on ourselves. Write on a piece of paper, "I am an artist." Post it where you can see it and read it aloud every day. It is not up to your friends or family to decide if you are an artist or not. It is up to you. You must overcome that pesky little fly whispering in your ear, "You aren't any good. You'll never be good enough." Swat that annoying fly away and get to work.

Date and save your drawings as you go. One day you will be shocked at your individual growth. The most gratifying part of these exercises is that once your eyes are open, you will never make drawings the same as before. It is time to unlock the artist inside of you!

Exercise 1

Practice writing your name in at least twenty different ways. Make your name fancy, plain, or with flair. Choose one that you can use to sign your artwork. Not every signature will be feasible to use in all mediums. Open up your creativity. All artists find their own way to sign their name. Artists use their last name, first name, both first and last name, or initials. This is more of a brainstorming activity to find a signature for your art pieces.

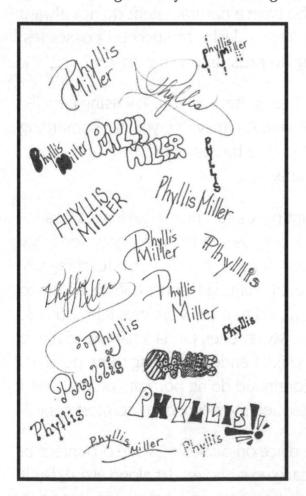

Consider which medium you intend to use more frequently as some signatures are more difficult to do with paints than with a pencil or pen. I tried several

ways on paper with my paintbrush before choosing a signature to use on my oil paintings. I had to feel like it flowed. Once I decided what my style was going to be, with the aid of my oil painting teacher and other students in class, I have continued to use the same style ever since.

Exercise 2

Draw a picture of a plant, such as a tree or flower, in the first box. Choose an object of your choice to draw in the second box. Save and date these pictures.

| Plants | Object |

Do not forget to store these pictures in a safe place. You will be repeating this exercise at the end of this book.

You are ready to begin your journey into an artist's world. Let's get started!

FINISH THE PICTURE

Half pictures help you to use symmetry in your drawings. A benefit of finishing pictures from both the left and right side is that you will be able to find out which side is easier to draw correctly. When you are drawing things from scratch, start on the harder side first. By beginning with the harder side first, you will be able to match the angles and proportions better.

Artists use many tools. One of those tools is the use of grids. The grid assists in getting marks in the right space whether the picture is the same size, smaller, or larger. Many artists use grids made of squares, rectangles, or diagonal lines.

Exercise 1

Finish the half pictures. Pay attention to which missing side is easier to draw correctly. Your drawing will have better proportions and be more accurate if you start with the harder side first in any drawing.

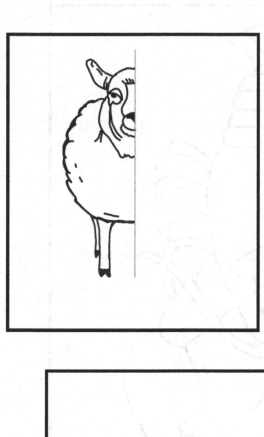

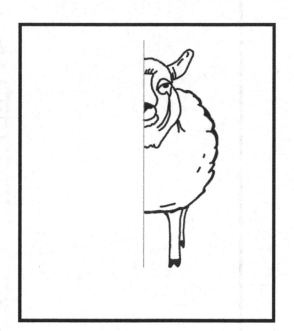

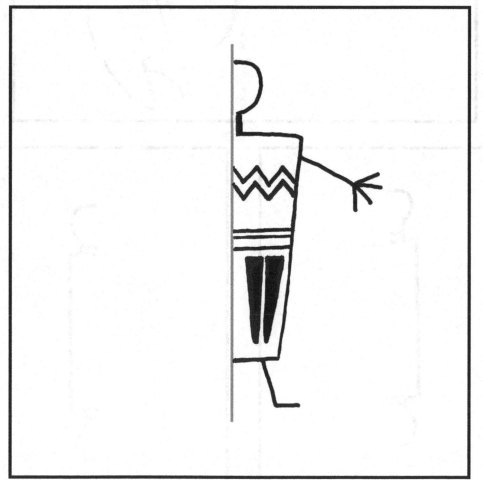

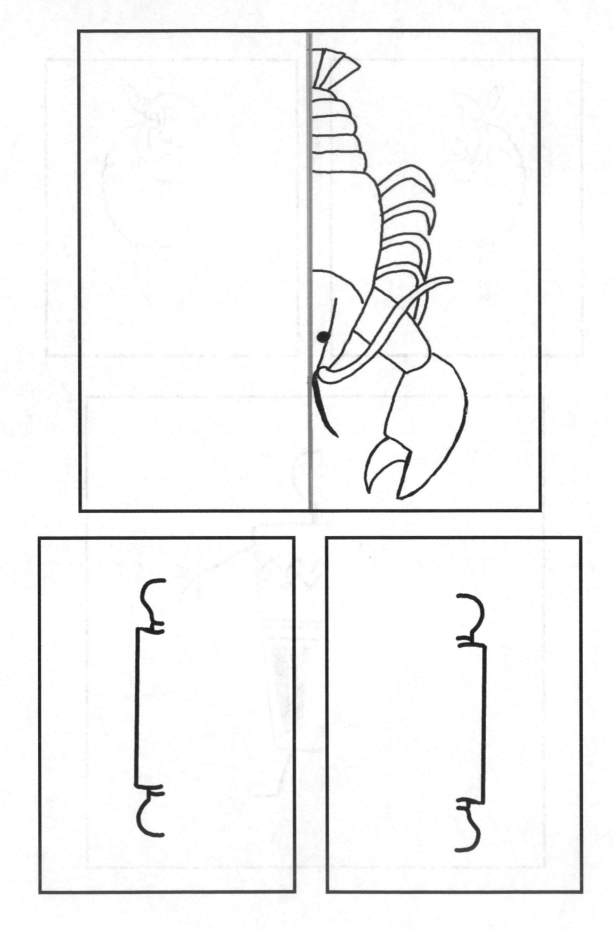

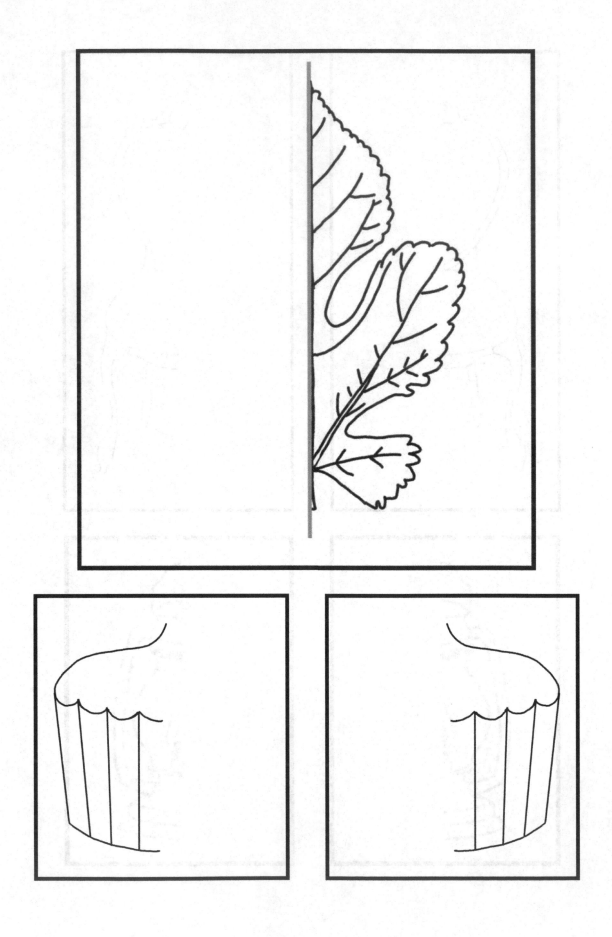

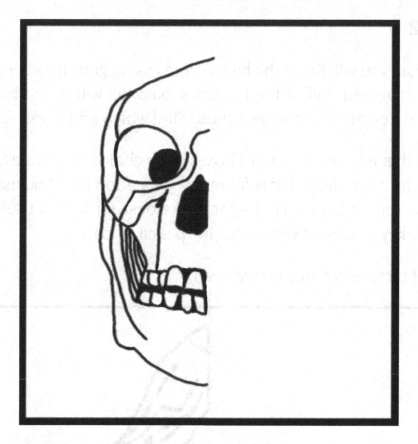

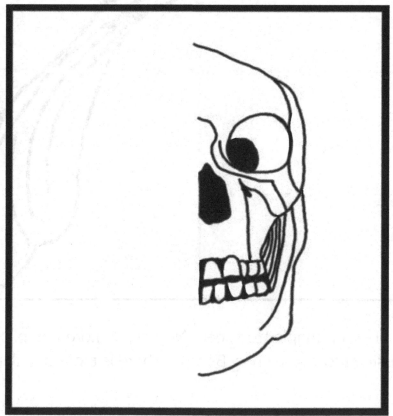

Exercise 2

In this exercise, you will finish the half pictures using grids in order to be more precise. The mirrored half of the images should fall within the boxes of the grid. Diagonal, rectangle, or square grids? Find which grid works for you.

I have found that a lower amount of boxes is my choice. The more fragmented a picture is, the more difficult it is for me to get a good flow. You may find that you enjoy numerous boxes. Find what works best for you. A useful tip is to place dots in key positions before placing pencil to paper.

The first grid picture is a maple tree seed.

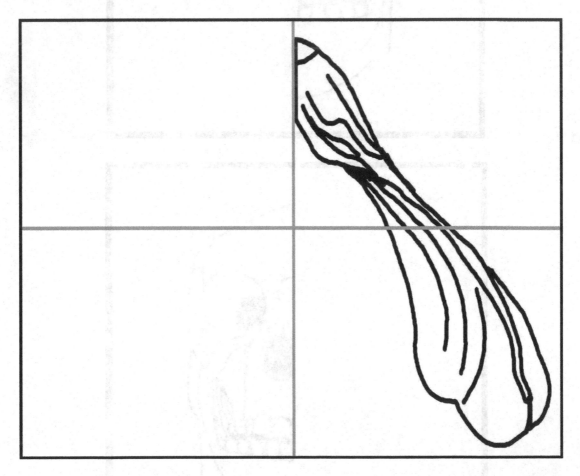

You have just drawn a maple tree seed. Now try a more complicated picture of a butterfly using more grid lines. Because there is more detail, the grids are smaller.

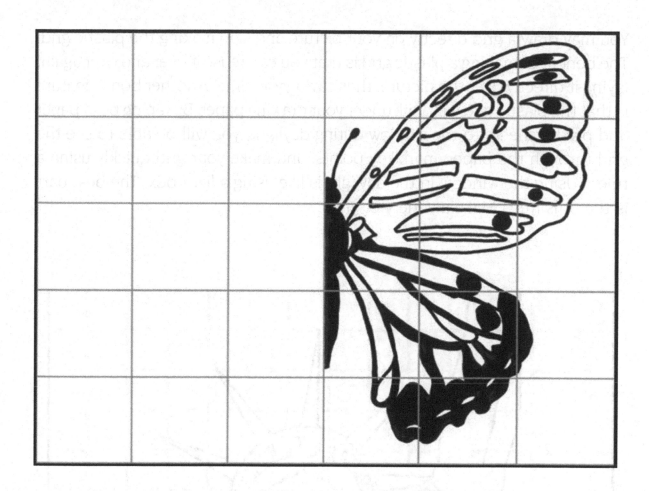

Exercise 3

For this exercise, you are going to draw a whole picture using grid boxes. Gather your supplies: piece of paper, ruler, pencil, permanent marker, and a sheet of clear plastic. You are going to make a grid on the paper. Measure carefully. Draw clean, straight lines. Next, take the sheet of clear plastic and lay it on top of the grid you drew on the paper. Using the permanent marker, mark the key points where the lines meet. With the ruler held down firmly, draw lines to connect the points. I made a variety of grids because I like working with less grid boxes when the picture is simple. However, with complicated pictures, I like working with more boxes to be able to focus on detail. Lay the clear plastic on top of the image you are going to draw.

Draw the same grid on your art paper or canvas. Make sure the lines are extremely faint to make erasing easier.

You may draw a grid directly on your picture and skip making the plastic grid. The benefit of making a plastic grid is that you can reuse it over and over again, laying it directly over the picture, thus saving you time. Another bonus feature is that the plastic grid will work under your drawing paper. By taping both paper and plastic sheets to the window during daylight, you will be able to see the grid through the paper, mark key points, and make your grid quickly using a ruler. (Using the window in the daylight is like using a light box. The best part is that it is free.) Make a variety of grids.

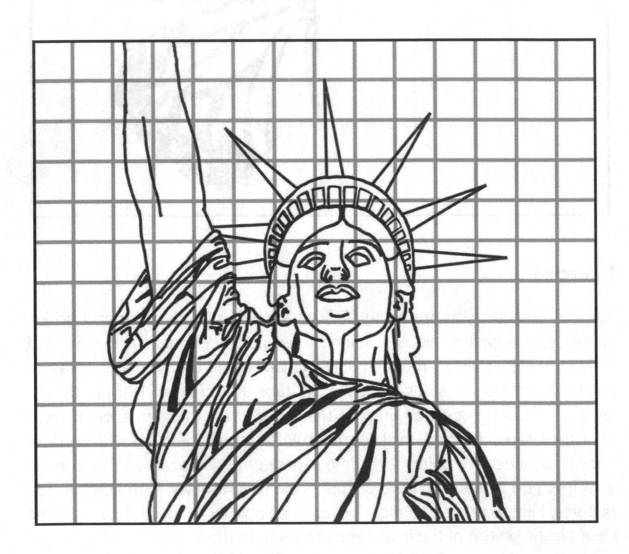

Look at each box as you draw. Make sure that each individual box looks the same as the original. It is too difficult you may say. However, you will never know until you try. Start with making small tick marks where a line starts and where it ends in each grid box. Do not draw the whole figure without paying attention to the grid! You need to look at each box individually. With so many boxes, it can be overwhelming. Lightly cross off the boxes as you go. Look at each box as a piece of abstract art. Do not look at the whole picture. This is a temptation for many students. They pick up their pencils and draw the whole figure very quickly. It is never in proportion. When you break it into single boxes, the finished product will look similar to mine.

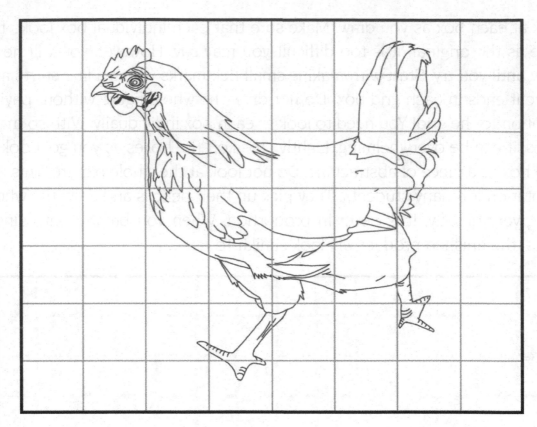

Original photo used courtesy of Bryce and Annie Park.

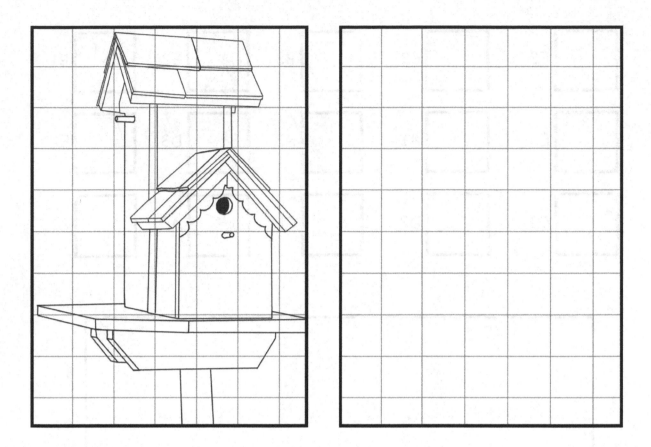

Original photo courtesy Gardner Village in West Jordan, Utah.

Exercise 4

Draw each piece in its proper place in the grid on the next page. You will find that although the squares are in random order, if you follow the shapes in each square, you will be able to make a whole picture.

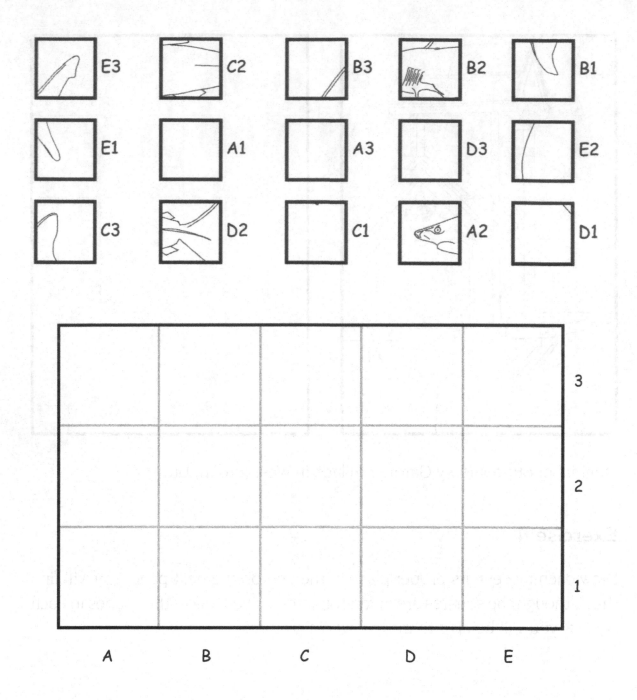

Exercise 5

This exercise is enlarging and reducing a picture. As with any of the grid exercises, look at the individual boxes. Do not attempt to draw the overall image. Pay close attention to what marks go in each square. This skill can be helpful, especially if you are trying to make a large drawing from a smaller sketch.

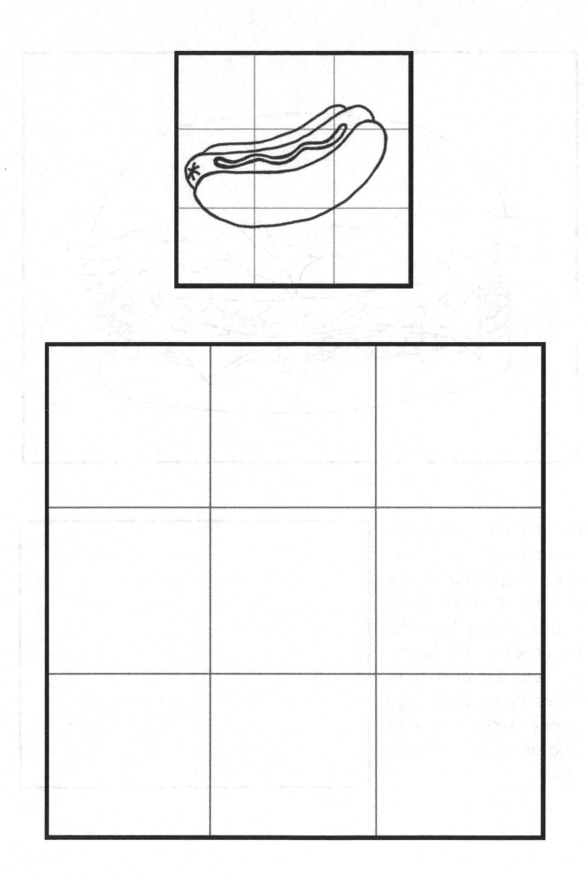

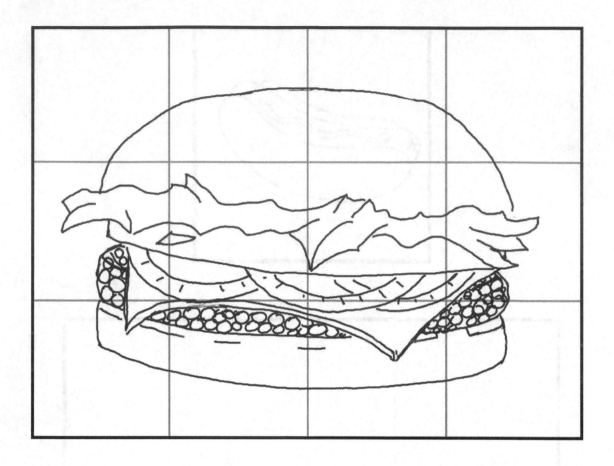

Now you will reduce the hamburger. Although you are reducing the hamburger just a bit, it is still good practice seeing how the lines fit within the boxes. You can enhance your abilities by taking a large poster or picture, drawing a grid on it, and reducing it down.

Exercise 6

The last grid you will explore is a grid that Vincent Van Gogh came up with in 1882. Many paintings and drawings of Van Gogh were painted or drawn on location. He had a local blacksmith help him create a grid that could be turned vertically or horizontally to aid him in his artwork. He drew a picture of the grid and described it to his brother in a letter. He would set it up to view landscapes and create compositions. The grid assisted in focusing on the best compositions and accuracy in placing images onto his canvas.

Because Van Gogh did many landscapes, I thought it best to try this type of grid on a rock formation called "Balanced Rock" in Arches National Park.

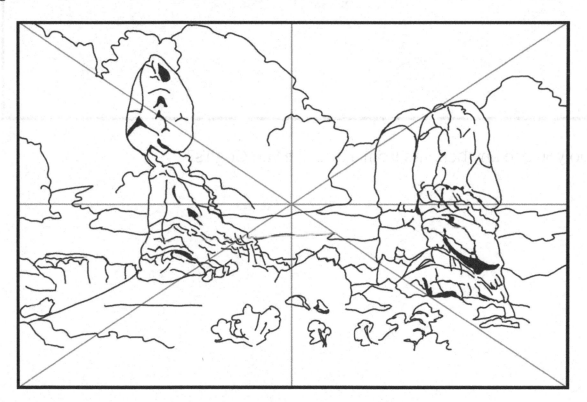

As before, look at specific lines. Pay attention how they come together in each triangular piece.

This is the end of the grid section. There are other types of grids. Practice with different types and see what grid you favor.

Do you see any benefits from a grid like Van Gogh's?

C H A P T E R 3

CONTOUR DRAWING

Being an artist requires a shift to the right side of your brain. The left side of your brain likes structure. The left side of your brain also likes to take objects you see, simplify them, and store them in your brain. By taking away the details, the images take less storage space.

Tricking the brain to avoid naming and simplifying images is vital. The goal is to switch to the right side of the brain by concentrating on details, not on the overall picture of what you are drawing. Playing music, while you draw, will help you transition to the right mode of your brain. Music without lyrics tends to work better.

Exercise 1

This first exercise will be with wire. Any bendable wire will work, but the wire needs to be able to hold a shape—like jewelry wire. I used a medium-gauge wire. You can sketch a simple shape of your own, use a picture, or have a picture in your head. Start wherever you want. I prefer to start around the eyes or nose if it is a person.

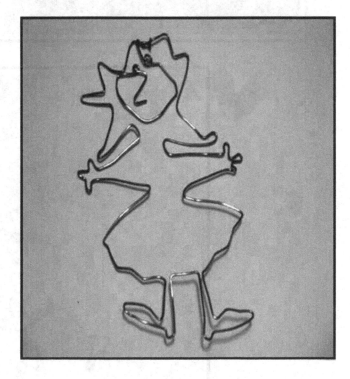

I had the image of the girl in my mind and moved from one part of the figure to another with one continuous piece of wire.

When you finish creating your wire art, cut off excess wire with old scissors or a wire cutter.

Lizards sway in a way that their bodies resemble the letter S. I took an ample amount of wire and bent it in half. Then I shaped the eyes and head. Continuing past the neck, I made the front legs, feet, main body, back legs, feet, and tail. I used jewelry pliers to work with since the wire was too thick to make sharp bends. I did not stop until I had made over twenty lizards. I used gold, copper, silver, and black wire. Adding designs to the main body added spunk to an ordinary outline.

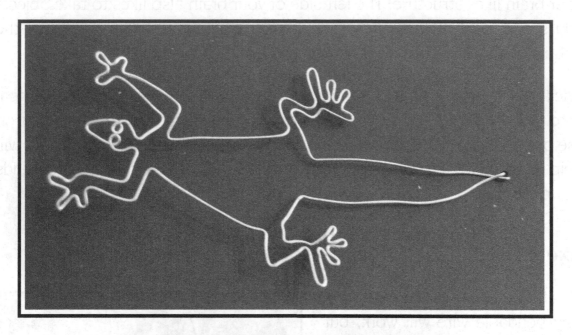

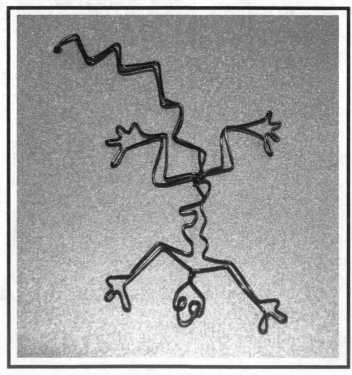

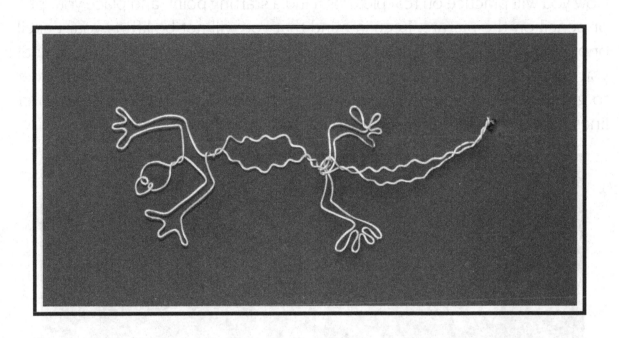

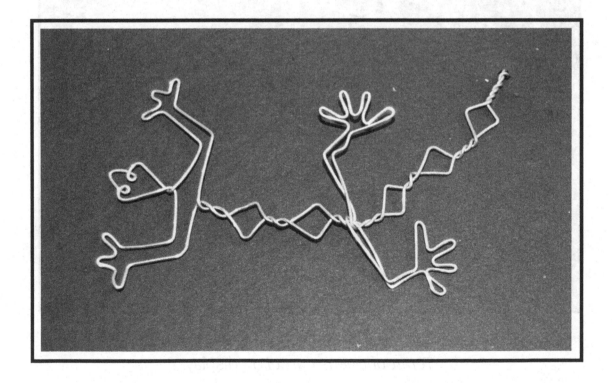

25

Exercise 2

Now you will practice on real pictures. Find a starting point, and place your pen or pencil on the picture. Keep in mind that you will not be lifting your pencil or pen once you begin. Trace the main details of the picture. Do not stop until you have finished. You may end up with lines where there are no lines in order to get to where you need to be next. You may even want to trace back over lines that you have already made to get to the next spot.

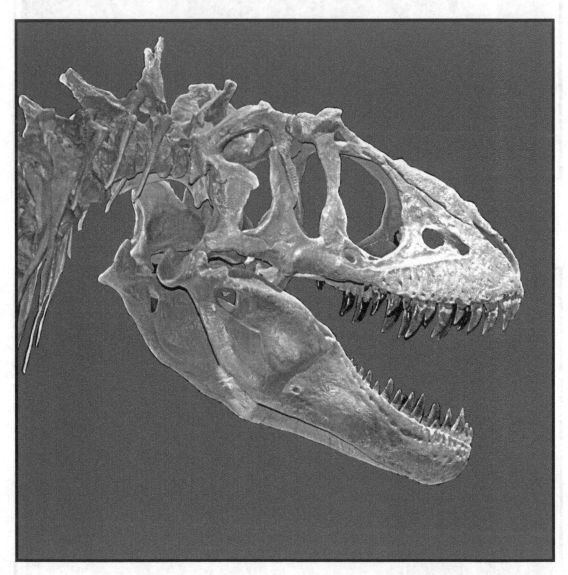

Courtesy of the Natural History Museum of Utah.
Teratophoneus curriei on display.

The contour drawings are not perfect. The assignments in this section are not for perfection; they are to train your eyes and drawing hand to work together. You will find your brain focusing on details better as you do this exercise and the ones that follow.

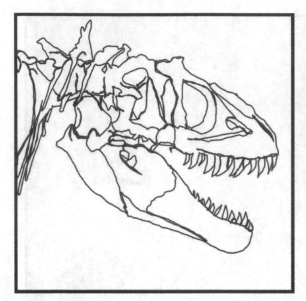 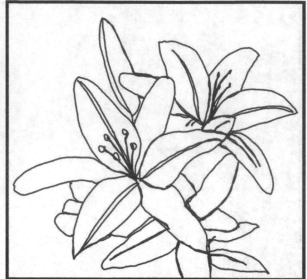

Exercise 3

The next challenge is blind contour drawing. Using the box in the book or a blank piece of paper, you will be drawing your hand. Angle the paper where it feels comfortable for drawing. It is much like choosing an angle for writing. If you decide to use a plain piece of paper, you will need to tape the paper down before starting.

Using another piece of paper may actually be preferable to the book. It is easier to start with something that is close in size to what you are doing. The picture below is an example of my hand that I drew.

Do not look at the paper unless you lose your place. You want to keep your eyes on your hand, not where your pencil is marking. It may look like a young child drew it, but that does not matter. Like other contour exercises, this is to help you open your eyes and see more details.

Place your elbow on the table, and relax your hand. Do not place it flat like you traced in kindergarten. Hold your hand in a relaxed pose. Draw the details without looking at the paper. Look for lines and curves on your hand and how they relate to each other.

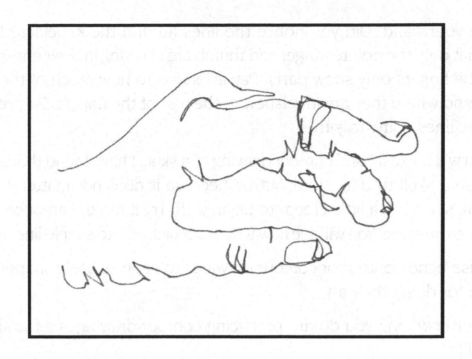

Evaluate your hand. Did you notice the lines around the knuckles? Did you notice that only the pointer finger and thumb are showing in their entirety? The rest of the fingers only show parts. Pay attention to how much of the fingers you see and where they are in relation to the rest of the fingers. Be precise on where the lines come together.

Next, you will make a blind contour drawing of a skull. I have found that students like to use a skull to draw from. Maybe because it does not matter if there is distortion, since it is a little creepy to begin with. Try it more than once. No two will ever be the same. You will see how to break a picture into simple line drawings.

Artists use blind contour or contour drawings to capture basic shapes and to warm up for doing their art.

No matter how long you do art, practicing contour drawing is as vital as any other skill.

Basic black lines exhilarate my spirit. They are so simple and uncluttered.

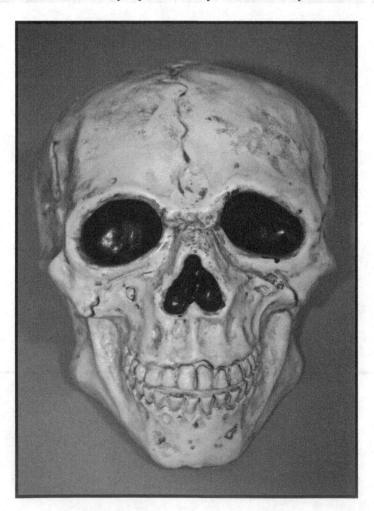

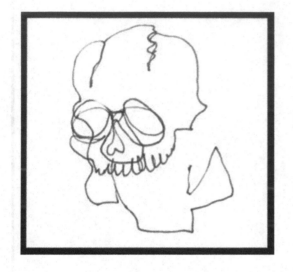

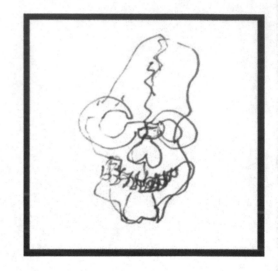

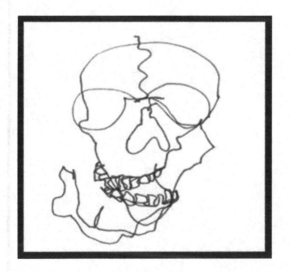

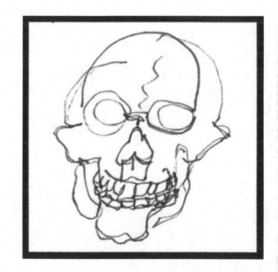

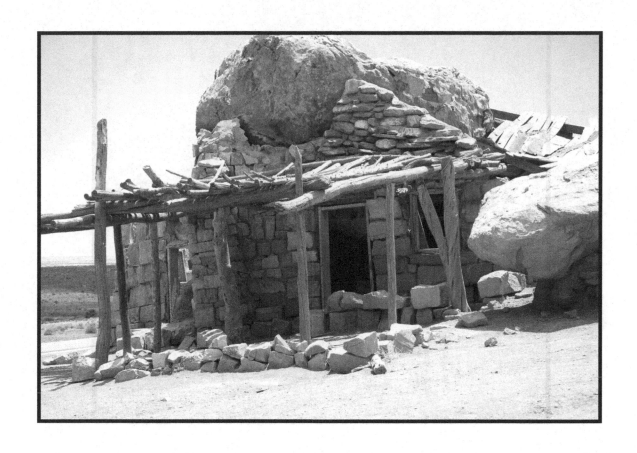

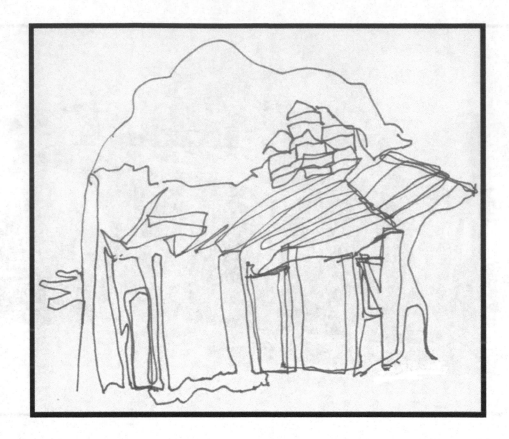

Use contour drawing with any subject. There are so many places to begin. Start anywhere and keep drawing.

A massive boulder breaking off the nearby red rock cliffs became the main part of this rock dweller's home in southern Utah. This was a remarkable use of resources.

Never stop to erase a line you do not like. You may want to use a pen, thus increasing your concentration and avoiding the temptation of fixing less-than-perfect marks.

Exercise 4

In this exercise, you will try drawings of people. The final products will not be perfect. Why would you ever want to become an artist if all art was going to turn out like a photograph? You would not. If you have an artist inside of you, you will desire to be unique, not absolutely picture perfect. Art would be boring without each artist's personality.

This was the first blind contour that I did of a teacher who was sitting by me. She did not look this bad, but I was thrilled with this drawing. This is when I discovered I had a love for simple black line drawings. I also realized that it trained my eye to trace the face and look at the curves and lines.

Draw a friend, or draw yourself while looking in a mirror.

Find a picture of a family member or famous person and do a blind contour of that person. Take pictures of people on a camera phone and practice. If a real photo is intimidating to start with, use a picture from a children's book.

Exercise 5

Modified contour is much like blind contour with one major difference: you may look at your paper as you go. The trick is to keep your eyes on the lines covering your hand and where they are located in relation to the rest of the hand. The drawing is a modified contour of my hand. Do not shade. Make a simple line drawing.

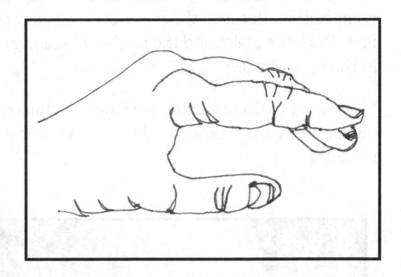

Animals can be fun and a challenging at the same time. These animals were from photos I took at my friends' farm. The sow with its piglet made for a great composition. Because the piglet overlaps its mother, you will want to draw it first. Draw the piglet and the mother pig separately in order to get the angles in the right directions.

If you want to do both pigs in a single continuous line, choose an area in the middle where they come together as that is where the busiest part of the photo is centralized.

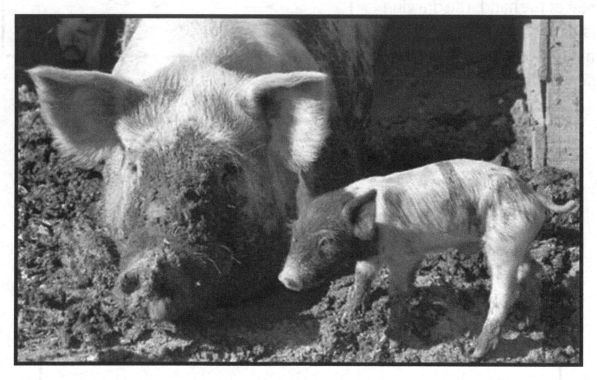

Photo used courtesy of Norm and Vickie Sherratt.

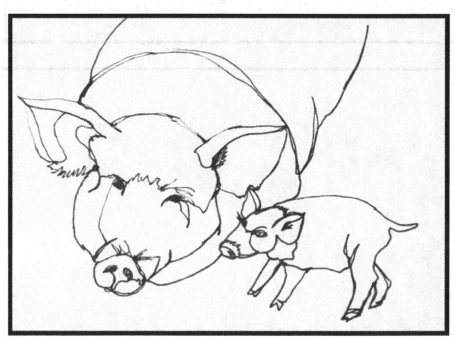

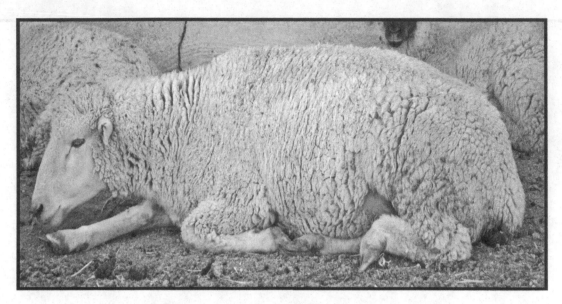

Photo used courtesy of Norm and Vickie Sherratt.

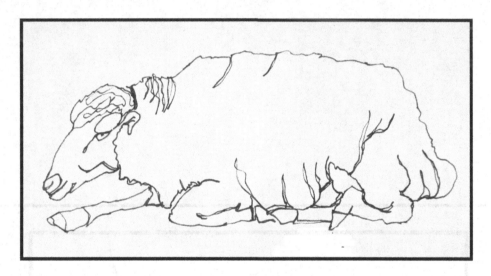

I reviewed my photos after visiting my friends' farm. I found that I had captured three different animals with their tongues sticking out as they posed for me.

Notice the tongue sticking out on the goat image below. Do not miss this in your drawing!

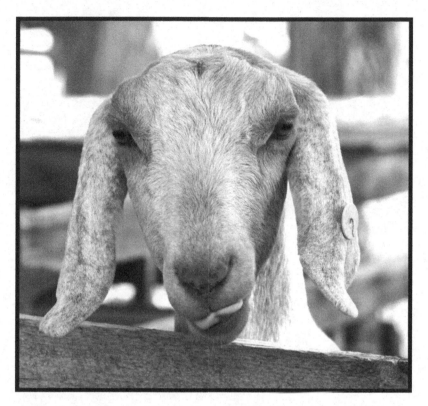

Photo used courtesy of Norm and Vickie Sherratt.

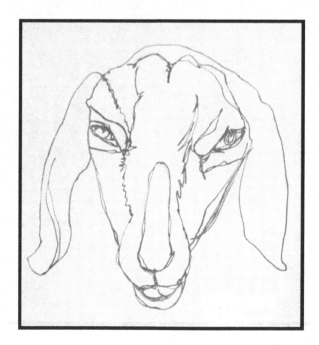

Where on the picture do you like to commit your first line? I like to start where it is the busiest. That way if I mess up on the detailed area, I know I will not get the best picture and can start over. Try more than once.

Exercise 6

This next exercise is what I named scaffolding contour drawing. To warm up, do a few blind contour or modified contour pictures first.

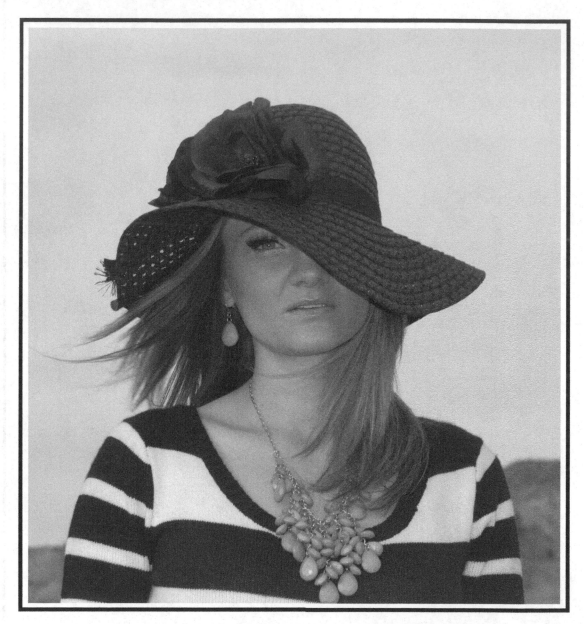

Photo used courtesy of Kalia Miller

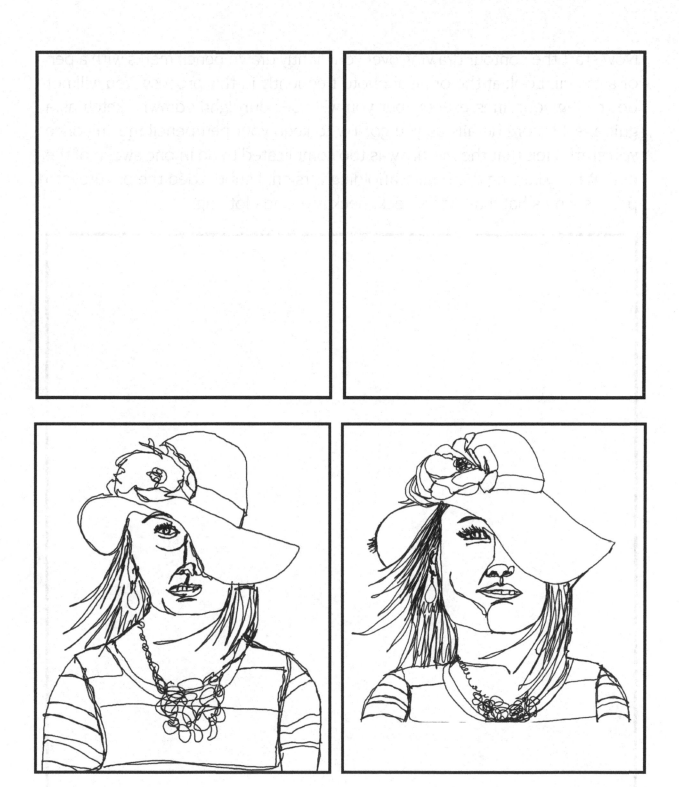

As you move to the scaffolding picture, you may want to tape the picture to the window with a plain sheet of copy paper over it. Lightly trace the photo with a pencil. Practice putting slight pressure on your pencil, and see if it will erase and leave the paper clean. Try this until you know how light your lines need to be.

Now start the contour drawing over your lightly drawn pencil marks with a pen or a pencil. Look at the original photo frequently in this process. You will not be tracing your lines exactly, but you will use your lightly drawn sketch as a guide. Add more details as you go. Try to keep your pen/pencil moving once you start. I felt that the picture was too complicated to do in one sweep of the pen. When drawing the final scaffolding version, I subdivided the picture into parts such as hat, hair, face, neck, necklace, and clothing.

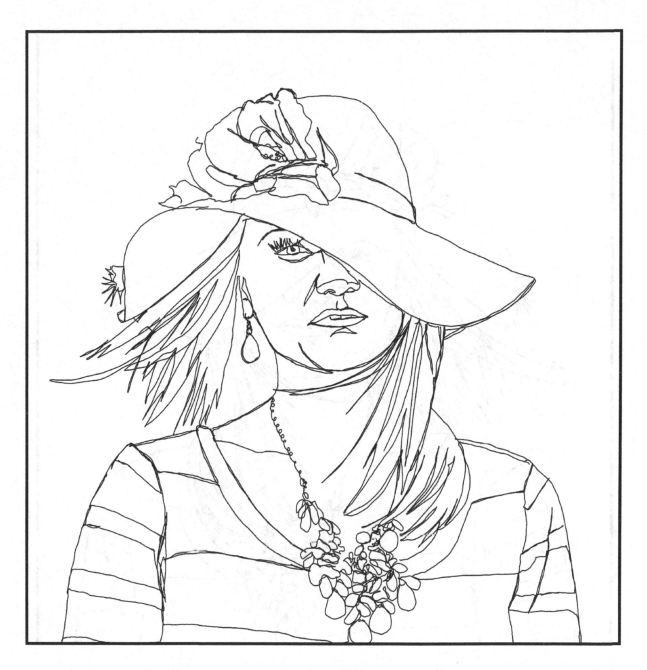

I came up with the name "scaffolding contour drawing" because the pencil lines give support. Scaffolding works great with multiple subjects, people, and scenery. Use this method when starting complicated contour drawings. You will find that you can eventually eliminate the scaffolding because your skills will increase.

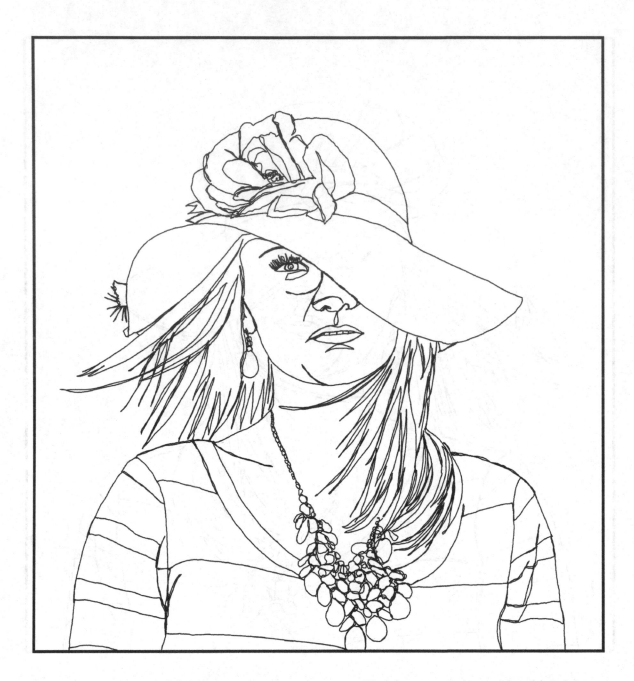

This was my second attempt with using scaffolding contour. I had to lift my pencil at least three times while doing this drawing. I recommend that you try several smaller pictures before attempting ones that are more complicated.

It is obvious that none of your contour drawings will be the same. Each one carries its own personality. You have to decide which one you like best.

Exercise 7

Cross contour is the last to explore in this chapter. Learn this well as it will benefit any type of art; including painting. Whether you are using pencil, pen, paint, or chalk, by making strokes that curve on round objects, you give the object a rounded appearance though the paper is flat. You will see the difference between making straight lines versus curved lines. This will give your art a more sophisticated level of quality. Little by little, your art will appear more realistic. Whether or not you want your art to look like real objects is up to you. Learn to draw real objects or people first. My motto is, "Learn the rules to break the rules."

Cross-contour drawing looks like an object covered with a cloth like the bat below.

Here are two intersecting lines. When you are doing this for the first time, pencil the outline of the object first. In the second box, you will see what the object looks like if you draw lines straight through your outline. The object has no form. How boring! In the third box, the lines stop where you want them to curve. (I sometimes use a ruler for this part.) Next, I put in the curved lines.

Try one of your own. Practice in the box below.

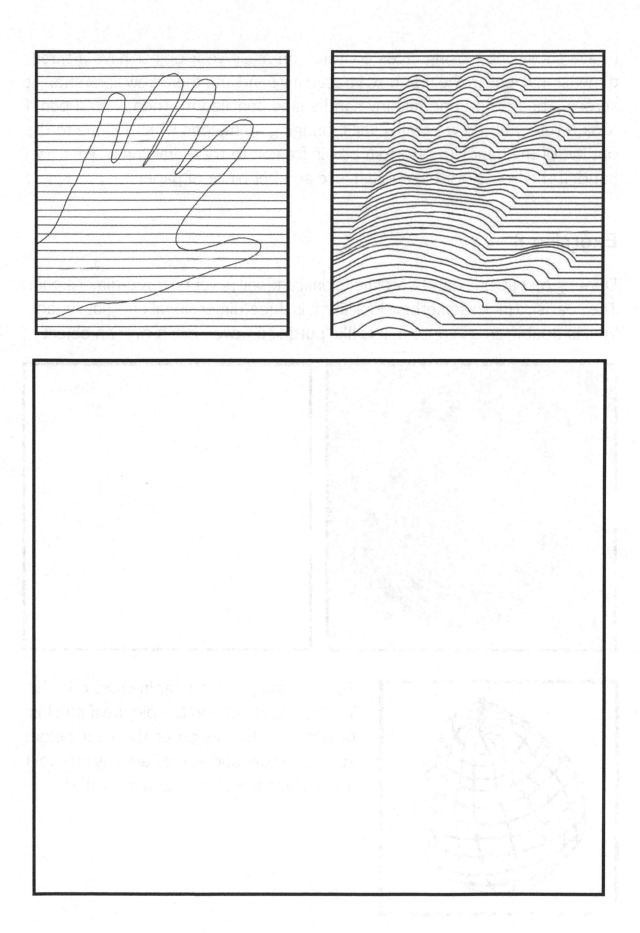

I have shown how using cross contour can make your object have a three-dimensional feel. In the first box, I traced my hand and then drew lines straight across. The second one has my hand shape penciled in. Then, with a pen, I took a ruler and drew parallel lines, bringing up my pen when I came to the outline of my hand. The bottom box is for you to try a drawing of your own hand. If the box is not big enough, use another piece of paper.

Exercise 8

Drawing on paper is only two-dimensional and will never be three-dimensional. The goal is to make something look like it is three-dimensional on a flat surface. This is double cross contour. It is like putting a woven mesh over an object.

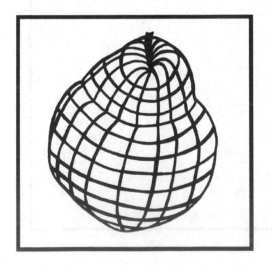

This is a sample of a pear in cross contour. You can draw right on the picture if it helps, or pencil in the shape of the pear before starting. Pears and apples are easy to do. I like starting where the stem is located.

CHAPTER 4

UPSIDE-DOWN DRAWING

Drawing is a conglomeration of lines, angles, and curves. It is looking closely at their relationship with one another that brings reality to drawings. This chapter is another step towards overriding our brains in its attempt to name and simplify the object we are drawing. We also have a tendency to see the object as if we are looking at it straight on instead of the way it really appears. You will comprehend this after doing the exercises in this section.

I found that students needed to do at least five attempts of the upside-down pictures. The first practice drawing is usually not the best, but you need to compare your first drawing with your last. Because I believe that concentrating on angles and curved lines are so important, I have included simple line drawings for warming up.

Exercise 1

Copy the lines in the boxes. Watch where they start and end. You might want to use a ruler for the first line drawing.

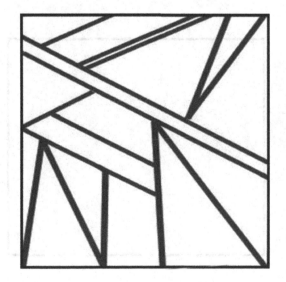

Exercise 2

Copy the pictures in each box. The image is upside down. Your drawing will also be upside down, side by side. After you are finished, turn the pictures right side up and compare.

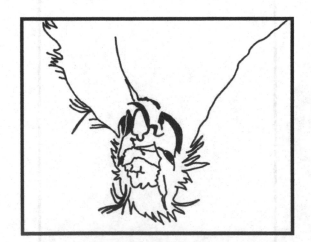

Original photo used courtesy
Norm and Vickie Sherratt.

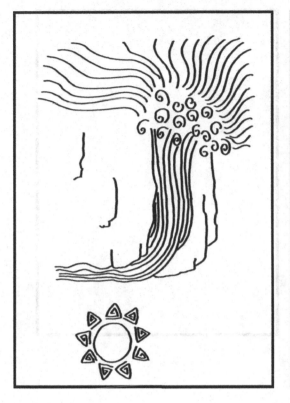

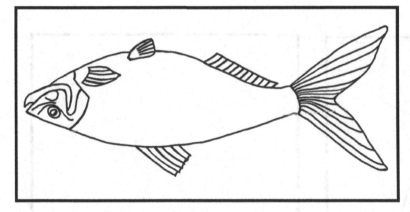

If this seems overwhelming, draw a light grid over the picture and the empty box. It will help break it up into smaller pieces.

Do not forget to turn the book upside down when you are finished to see how well you did.

I used coloring book pages for practicing this exercise when I was teaching.

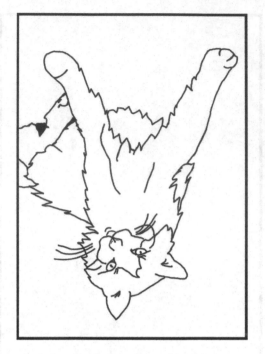

Original photo used courtesy
Norm and Vickie Sherratt.

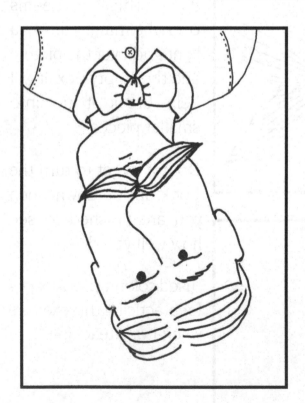

Original photo used courtesy of Gardner Village in West Jordan, Utah.

CHAPTER 5

POSITIVE AND NEGATIVE SPACE

In art, the understanding of positive and negative space is essential. The positive space is the object(s) and the negative space is the space around and between the object(s). The one thing I have found as I have concentrated on the negative and positive space is that it helps you see how the object fills the space and to turn off the part of your brain that is trying to tempt you to draw it straight on. Often we see an object for what it is and rarely as it is in the composition. You must overcome what your brain is telling you and concentrate on where the positive and negative spaces meet.

One of my favorite artists/illustrators is David Wisniewski. He enjoyed shadow puppetry and made figures to use in Shadow Theater. He applied this talent and the art of cut paper, or what Japanese call kirigami, to make illustrations for his children's books. The art in his books are solid colors cut into shapes with details.

Photographers use this method to create a silhouette where the figures or shapes themselves are black forms, distinguishable from the background.

In painting, I found that this concept was useful as I tried to separate the object from its background. There needs to be some kind of an edge where the space between the positive and negative meet. That means that the area around the object needs to be darker or the object itself needs to be darker.

Exercise 1

First, draw the figure as you see it filling the box. Stay on the outside edge. You do not need any details, only the shape. Did you notice that what your brain is telling you to draw is a different shape than what you are seeing?

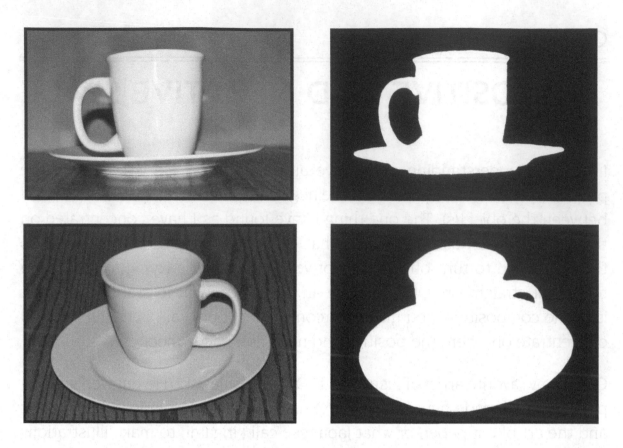

The first mug is how we usually think of how a mug should look. It is straight on, and your brain says, "This is a mug." That is it. It creates an icon for the mug. Skew the picture at a different angle and your brain still tries to tell you to do the first drawing. After all, that is what a mug looks like.

A watering can does the same thing as the mug. Notice the two pictures and the two positive and negative space pictures.

Each of the watering cans fill the space differently. The first is a straight-on look at the can. It can be a bit boring. The second one angles slightly.

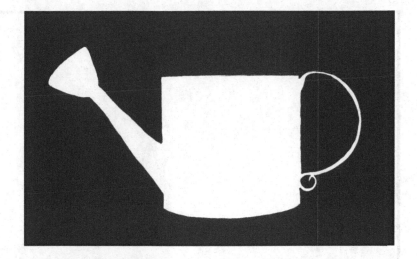

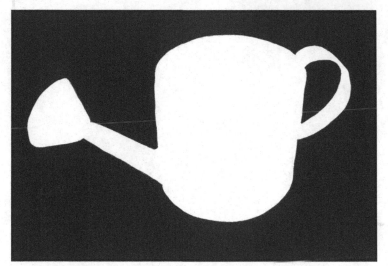

If the outline of a shape is off—in other words, where the positive space meets the negative—there is no point of putting in more effort on the details as you push to adding details.

There could never be a greater time to do art. You have tools at your disposal like never before. You can find pictures to practice drawing on the Internet, but I challenge you to take your own pictures. Whether you take pictures with a cheap camera or a phone, it does not matter. Take pictures at different angles. Notice the differences on how they fill the space. I promise you that taking pictures for your own artwork will be much more satisfying. Start now to create a database of pictures that you can use for art in the future. I have several thousand photos to pull from. A majority of the art I create is my work from start to finish. Try photos of your own.

Exercise 2

My first attempt at using positive and negative space as a form of art was born out of necessity. I had just returned from England after having visited the towns where my grandmother and great-grandmother had been born. I had a poor-quality camera that did not do well when used in rainy weather. Of course, it rained every day I was there. My pictures turned out lousy. I wanted to preserve the memories in some way. I decided to do a background with a watercolor wash and placed cut paper on top of it, using positive and negative space. Success.

You will need a small pair of sharp scissors. (I like to use embroidery scissors.) Take a colored paper and a black paper. Outline the object and positive space on the black paper and cut it out all in one piece. You will find in later pictures that breaking it up into more pieces is necessary. Glue the cut out picture on top of the colored paper.

You can also do it the other way around. Outline the shape of the main object on white paper, cut it out, and glue it on a black background.

This is an example of my picture looking down the street in Halifax, England.

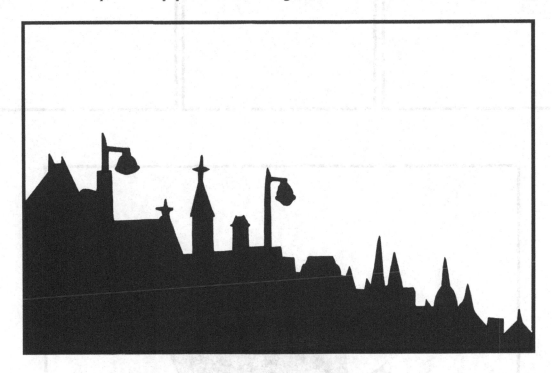

Simple calligraphy works well in positive and negative space. Here are kanji to practice.

| Chie – Wisdom | Mori – Forest | Ai – Love |

The building silhouette I chose for showing positive and negative space is Tsu Castle in Tsu, Japan, where I lived for a short time years ago. The photo hid a corner of the building because of tree branches laden with leaves. The camera I had was not a 35 mm or a digital. It was a pocket camera with very low resolution. Castles in Japan have great character and form. I took this bad photo and drew the outline. Whenever you try an outline, look carefully to see if you can still distinguish the image, if the image was solid black or white.

With any outline you choose, get the main details on the outer edge of your image. Leave out details that could confuse your positive shape.

Do the same thing with the saguaro cactus. Make a light pencil drawing of the main shapes. Then cut it out and attach it to a plain or watercolor background. There is a box below if you would like to draw it instead. I would leave off the weeds around the bottom of the cactus, as they distract from the outline.

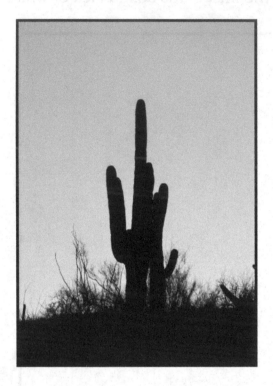

The image that follows is a positive and negative outline of a man with a hat. You may want to try a different color in the boxes below. Do not forget that positive is the object or person. The negative is the space around and between.

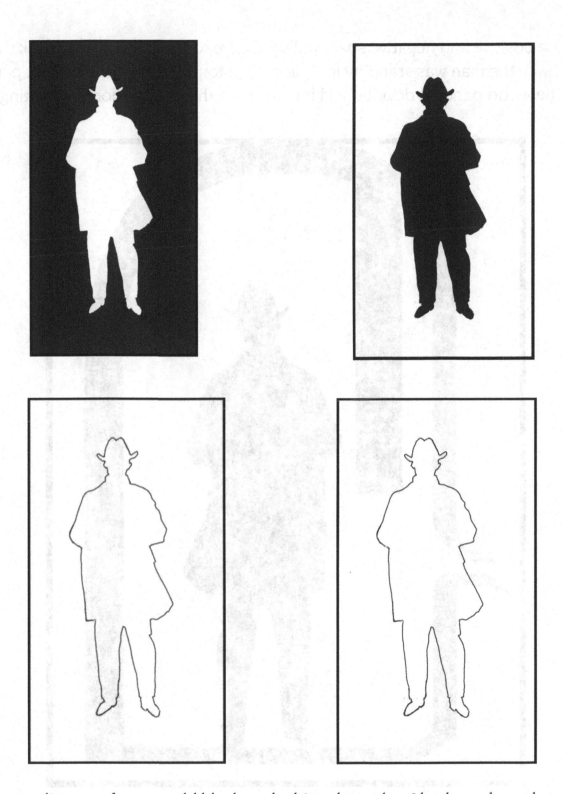

The outline was from an old black-and-white photo that I had purchased at an antique store. Even though the picture was not very clear and was tiny, I was still able to have fun with this picture. That is the best thing about art. You can take a poor-quality picture and turn it into an appealing work of art.

Using positive and negative space pulls your eye to the object itself. I took the archway the man was standing in, a bit of the stonework, and the darkest part of the wood paneled door behind him to make the picture more interesting.

This is a picture of Haystack Rock at Cannon Beach in Oregon. I edited the photo from color to black and white. I focused on the dark areas. What would you focus on?

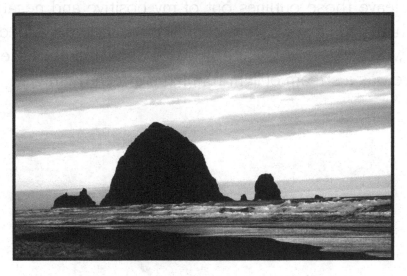

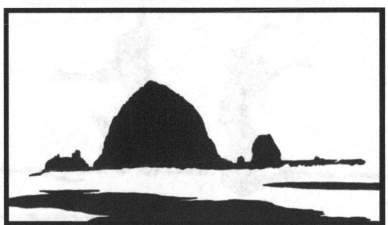

On a trip to California, my daughter, Emerlie, took several photos of silhouettes in the setting sun on the beach. The original photo had a trace of land in the ocean on the horizon. There was a ship at the right and the left of the frame. I decided to leave those outlines out of my positive and negative outlines because of their size. It would have confused the viewer. I added a few lines of my own. I wanted to leave a white strip down the middle of the two figures because there was a stream of light running between them.

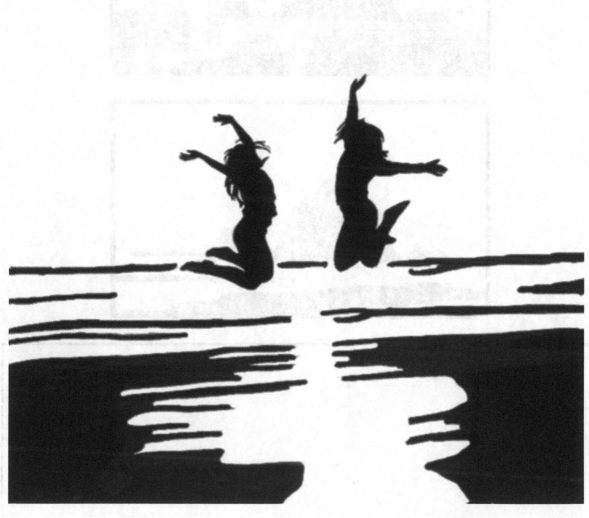

Original photo used courtesy of Emerlie Grandy.

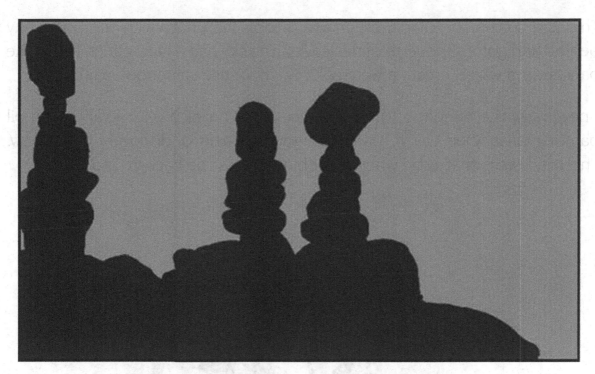

Original Photo used courtesy of Shan Miller.

This is a picture of a Japanese maple. I took the photo with the bright sky behind and got a silhouette of the leaves. The sky had a hazy effect. Leave the background white, create a watercolor wash, or use scrapbook paper.

I never saw the benefit of these exercises until I took a photography and oil painting class. One day you will have your moment of discovery, if not now. There is always that edge where the object meets the background.

Find a photo or picture of your own. Focus on the line between the positive and negative space.

CHAPTER 6

BLOCKING IN

The next skill is "blocking in." Look all around you. In the visual images that you see, break down each one into simple geometrical shapes. Can you see triangles, squares, trapezoids, rectangles, and circles, both large and small? By breaking images into simple geometrical shapes, it ensures more accurate angles and proportions.

Take an object, scenery, or photo you want to draw. Make light sketches of the item(s) using simple basic shapes. When starting a new drawing, this basic skill helps to fill the paper or canvas. The focus is shape and placement. Details come next. The image emerges by refining the lines and cleaning up the picture.

Exercise 1

In this exercise, you will be "blocking in" pictures. Notice that you will be looking at the original picture; drawing a light outline of the geometrical shapes, and cleaning the shapes up by erasing and refining your drawing. I used to think that you had to see the shapes the exact same as someone else. That is not true. You may see the shapes differently. Remember, no one is right or wrong on this assignment. I broke the pictures down into the geometrical shapes that I saw. If you see it differently, that is okay. Do it the way you see it.

After drawing your basic shapes, start erasing and refining the image. You may choose to put in more details than I did. I did not worry about fine details because I focused on getting the main lines drawn correctly.

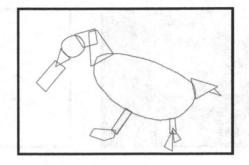

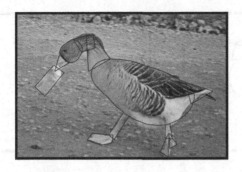

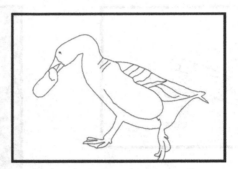

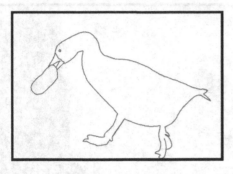

The first picture is a goose carrying a hoagie bun. He was busy scurrying back and forth, hoarding the bread, while being chased by the other geese. He finally dropped the bread, and a gaggle of geese dove at it.

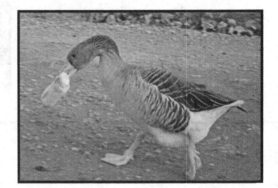

I blocked in the picture with geometrical shapes, smoothed out shape, and erased unnecessary lines. I included some final details that refined the goose. You may want to put in more details than I chose to do. Were your geometrical shapes similar to mine?

This seagull kindly rested for me to take a photo while traveling up the Oregon coast. Birds tend to pose for me from time to time.

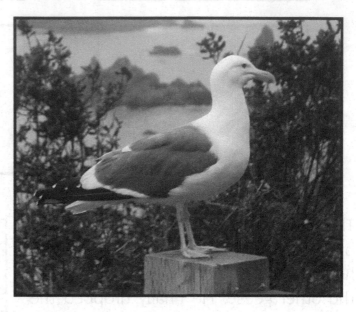

What shapes did you choose? Were they close to my shapes? Step-by-step, clean up the outline of the seagull. I want to emphasize that the blocking in needs to be light. You will want to erase lines as you clean up the picture.

This is a witch from Gardner Village in West Jordan, Utah. It is my favorite witch because it has the most personality of all the witches haunting the village during the month of October.

Watch for main shapes, and then clean it up. You do not have to draw precise geometrical shapes.

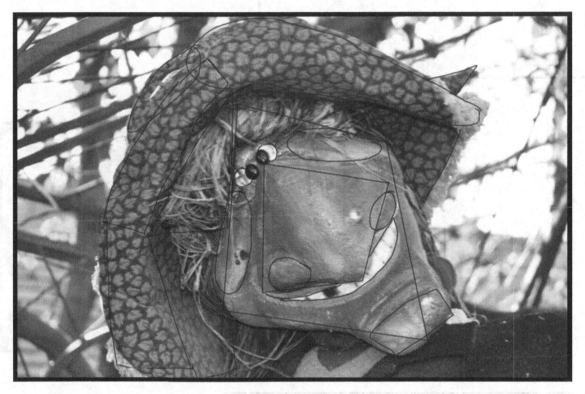

Original photo used courtesy Gardner Village in West Jordan, Utah.

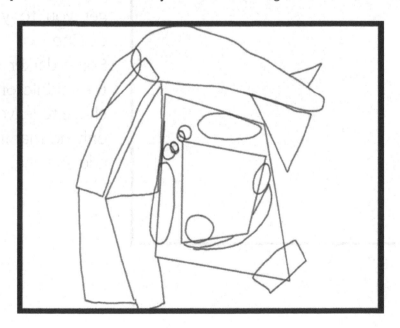

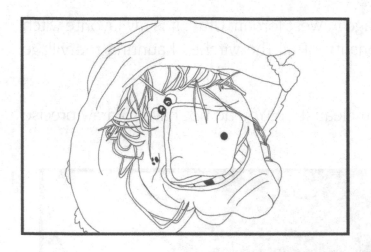

With more practice, you will be able to draw closer to the final object from the beginning.

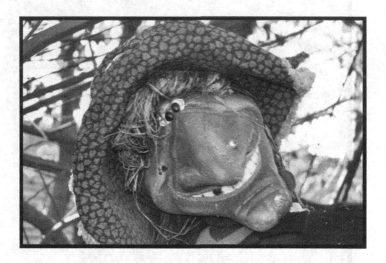

Use shapes that will best get you to your desired outline of the witch. Some darker lines, like in the middle of the nose, I chose to leave off. I would only do that if I wanted to add shading.

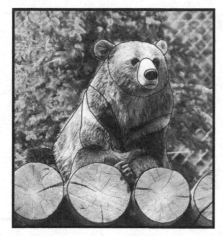

Original photo used courtesy of
Hogle Zoo in Salt Lake City, Utah.

Try a bear sitting on a rooftop. I included the logs to give the bear a base to sit on. The eyes were extremely dark in the shadows, so I had to make the eyes the way I saw them.

Some shapes are obvious, like the round end of the logs. Other shapes are not so

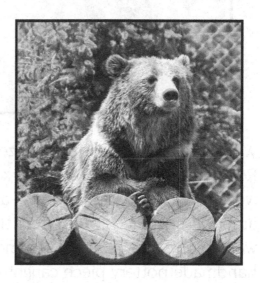

obvious. Notice the triangular pieces and ovals. They are not precise shapes. As you continue sketching figures of any shape or size, you will lean more toward irregular shapes.

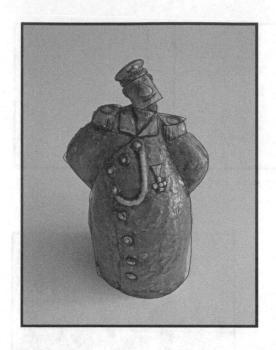

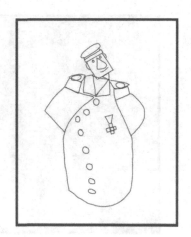

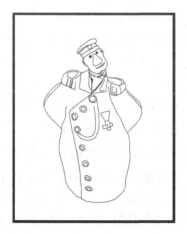

While on a trip to Prague in Czech Republic, many of my fellow workers were buying crystal, garnets, and amber. I searched for an item that was unique. The marionettes and a handmade pottery piece caught my eye. I love this small handmade police officer.

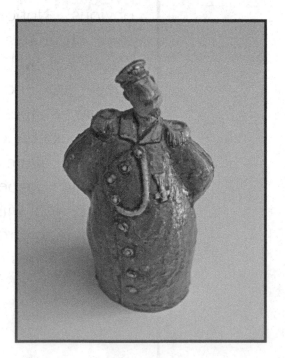

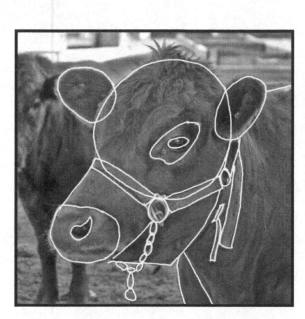

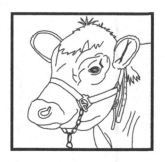

Photo used courtesy of Norm and Vickie Sherratt.

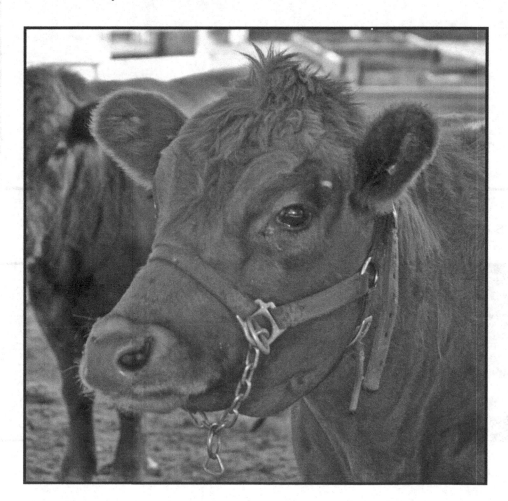

Flowers are an easy subject for blocking in.

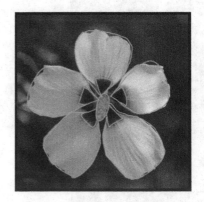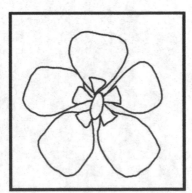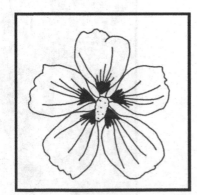

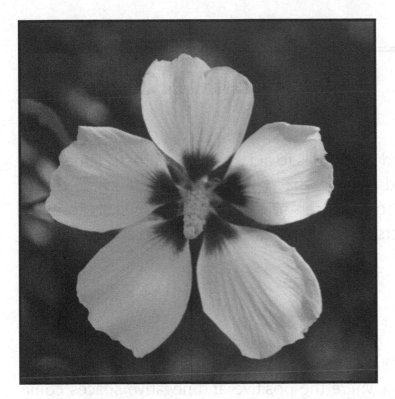

Draw the simple triangular petals of the flower. I added in a few of the contrasting areas, such as the inside of the petals. Properly place the stigma, or center of the flower, at the correct angle. I included a few of the lines running through each petal to add personality.

C H A P T E R 7

COMBINING SKILLS

In this book, you have learned many skills to aid you in your artistic endeavors. By using grids, negative and positive space, turning pictures upside down, and the window as a light box, you can now combine these skills to make accurate renditions of objects. These tools can be used one at a time, or in combination.

Exercise 1

The first object is a stool. Draw a light grid over the picture. Start with an outline of the stool watching where the positive and negative spaces come together.

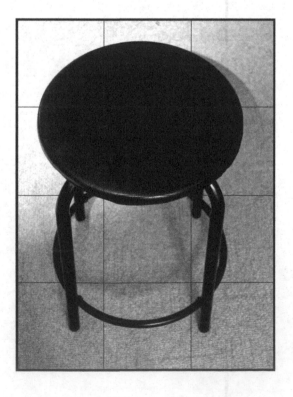

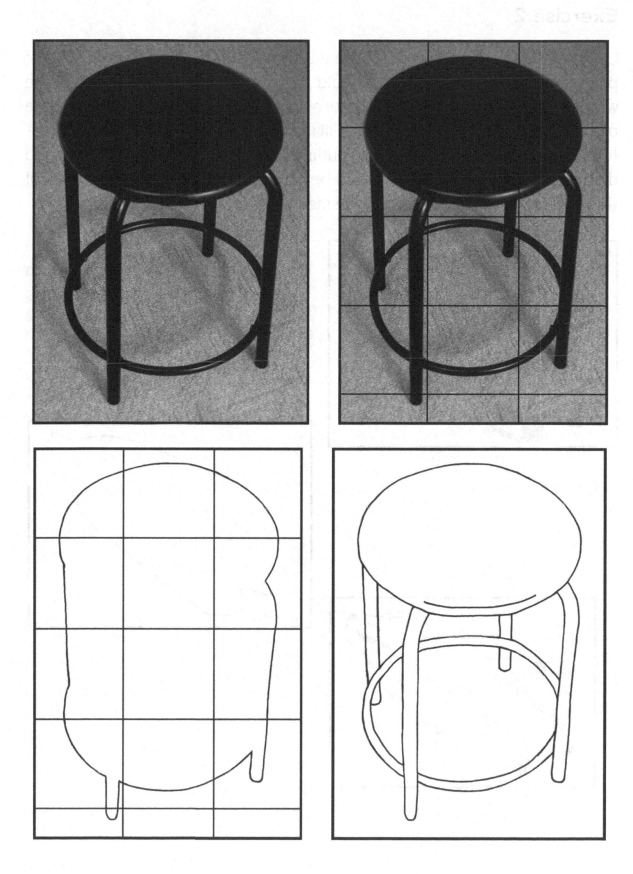

Exercise 2

Use a picture that allows light to permeate through it. Place a plain piece of paper on top of the picture and hold up to a window during daylight. The window with the daylight will replicate a light box. Trace the outline where the positive and negative spaces meet. Fill in the details later. In the exercise that follows, concentrate on the simple outline. Study the examples, and then add details. Shading the bananas would be the next step; however, the focus of this exercise is concentrating on the main lines.

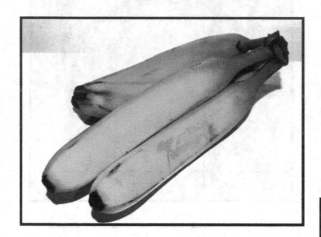

When you are not sure if you are drawing lines at the correct angle, turn the picture upside down. Sometimes it is easier to catch your mistakes.

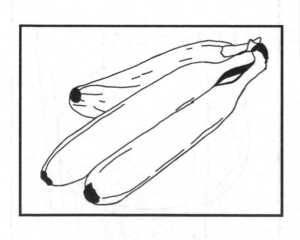

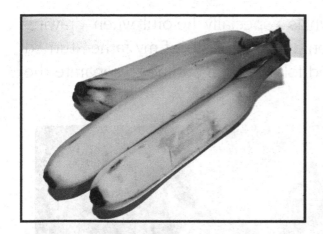

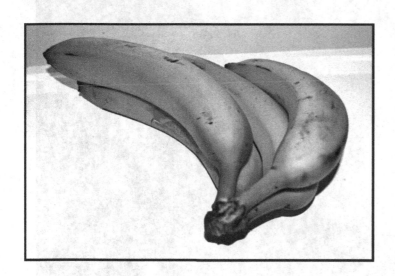

Exercise 3

Combining the grid and upside down is especially helpful when drawing complicated pictures, such as a person. I took a photo of my father, turned it upside down, drew a grid over it, and followed the outline to separate the positive and negative space.

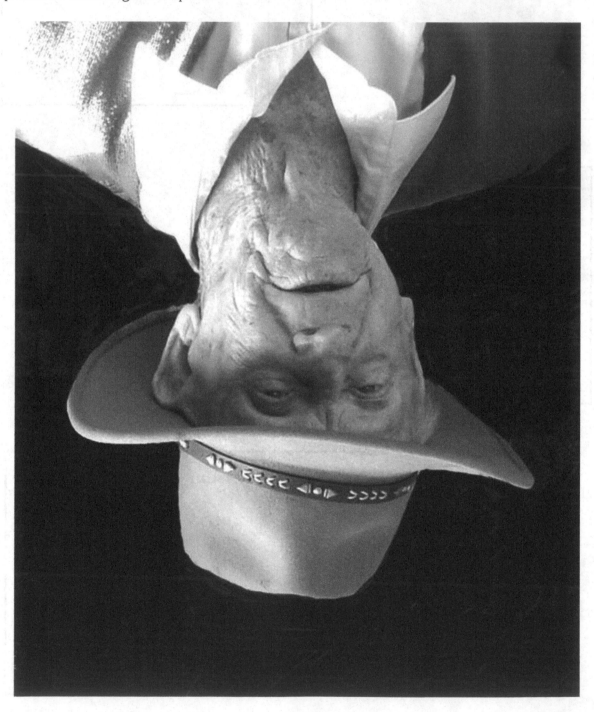

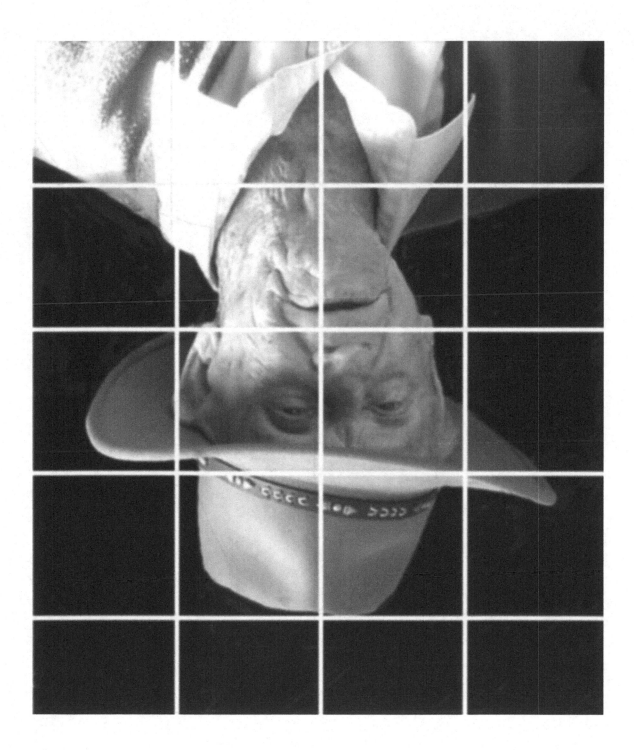

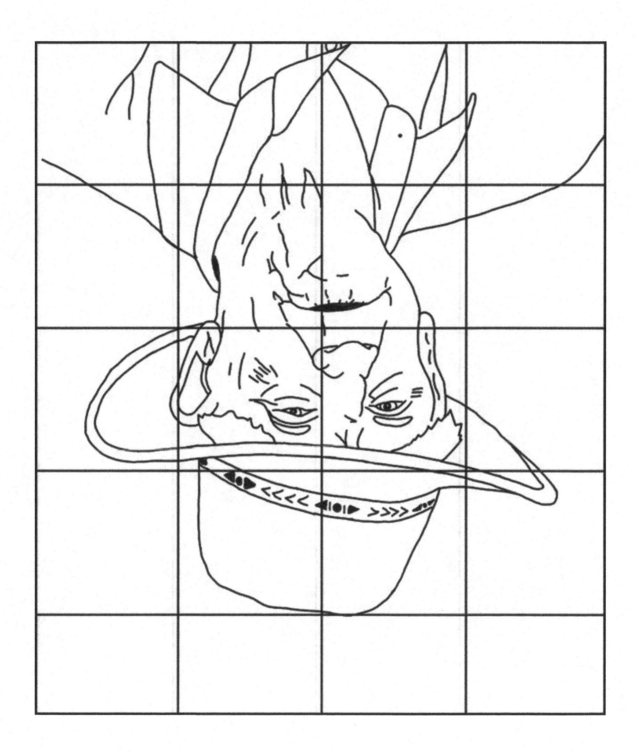

CONCLUSION

Are you ready to see how this book has changed your artist's eyes? At the beginning of this workbook, you drew a plant and an object. You may choose the same pictures you used at the start, or find new images. Use an actual photo or objects, if possible. Do not just draw it from memory, or the simplified symbol will take over.

| Plants | Object |

Compare these drawings with the ones you drew before doing the exercises in this book. Do you see a noticeable difference? I have seen these assignments change a multitude of students. You have opened up your eyes to art by focusing on the lines and moving to the details. Continue to grow by learning a variety of art skills.

ABOUT THE AUTHOR

Phyllis Miller's passion is guiding people to their inner artistic talents, a skill she refined teaching school for 19 years. She has her Masters degree in Elementary Education. Phyllis has five grown children who each have their own creative talents. She lives with her husband in Utah.

Printed in the United States
By Bookmasters

Printed in the United States
By Bookmasters